LAUNCH IT!

123 LAUNCH IT

How to Start
a Portrait Photography Business

(*Even when you think you can't*)

by Angela Goodhart

COPYRIGHT NOTICE

Copyright © 2019 by Angela Goodhart.

All rights reserved. This book or any portion thereof may not be reproduced or used in any manner whatsoever without the express written permission of the publisher except for the use of brief quotations in a book review. Printed in the United States of America
www.123LaunchIt.com

No part of this publication may be reproduced, stored, or transmitted in any form or by any means — electronic, mechanical, photocopying, recording, scanning, or otherwise — without the prior written permission of the author except as permitted under Section 107 or 108 of the 1976 United States Copyright Act. Requests to the author and publisher for permission should be addressed to the following e-mail: hello!@123LaunchIt.com.

Limit of liability/disclaimer of warranty: While the publisher and author have used their best efforts in preparing this book, they make no representations or warranties with respect to the accuracy or completeness of the contents of this document and specifically disclaim any implied warranties of merchantability or fitness for a particular purpose. NO warranty may be created or extended by sales representatives, promoters, or written sales materials.

The advice and strategies contained herein may not be suitable for your situation. You should consult with a professional where appropriate. Neither the publisher nor the author shall be liable for any loss of profit or any other commercial damages, including but not limited to special, incidental, consequential, or other damages.

To my children.

Believe in yourselves –

Anything is possible!

Trust in the magic of new beginnings.

PREFACE

Welcome!

So you want to start a photography business! That's wonderful news. It's going to be an exciting journey, one that will sometimes frustrate and challenge you but also be personally and financially rewarding.

I wrote this book to be the Chief Encouragement Officer for every woman who has dreamed of owning a photography business but, for whatever reason, tells herself she can't.

I believe everyone who wants to start a business, regardless of their insecurities, should be encouraged to share their gifts with the world.

Several years ago I launched my own portrait photography business, wrestling with self-doubt and insecurities along the way as an introverted, overwhelmed mom to three

children with some unique needs. This venture has been a huge blessing. I've loved the flexibility of my job, and it's been a genuine joy to generate income while sharing my creative talents in my community.

 I'd love to help you do the same.

TABLE OF CONTENTS

1 — Dream It
Ch 1: What Do You Want?.................1
Ch 2: How Will You Get It?...............5
Ch 3: What Can Stop You?...............9

2 — Plan It
Ch 4: Acquire Your Gear...............35
Ch 5: Develop Your Talent............53
Ch 6: Build Your Portfolio.............71
Ch 7: Set Up Your Business..........79

3 — Do It
Ch 8: Launch Your Business.......109
Ch 9: Wow Your Customers.......112
Ch 10: Grow Your Business........116

Conclusion

1
DREAM IT

> *"All our dreams can come true if we have the courage to pursue them.*
>
> *--Walt Disney."*

Chapter 1. What Do You Want?

Since you're reading this book, it's probably safe to say you want to start a successful photography business. But what does success mean to you? And why photography? Why not knitting or web design or interior design or real estate or something else?

Nailing down these details is important, because a vague yearning to start a business will not help you act in a focused, sustained way. You'll experience ups and downs as you build your business, and the downs can be demoralizing and discouraging. Many would-be professional photographers never start their business, and those who do often quit within the first year or two. Understanding exactly what you are trying to achieve and why you

started down this path can motivate you to keep plugging away when life gets complicated.

What is in your mind's eye when you think about your photography business? Grab your laptop or a sheet of paper and quickly write down your initial thoughts.

There are so many possibilities. Who inspires you? What types of photography do you enjoy looking at? Maybe you want to be a fashion photographer and photograph models in artistic and edgy ways. Maybe you want to be a birth photographer, a witness to the miracle of life. Or maybe you want to be a wedding photographer, like your neighbor down the street who runs a thriving business. Take the time to hash out your vision.

Next, imagine your business one to three years from now. Be as specific and detailed as possible about your dreams. What is the positive impact on your family's income? How does the money you earn improve your standard of living? Is your business a force for good in your community?

Spend a few minutes thinking about why this vision matters to you and write that down as well. Write from your heart, not your head, and don't worry if your reasons seem too

mercenary or sappy — this is a personal document meant to keep you on track, not something you need to share with the world.

When I started my business, I wanted to be a successful portrait photographer who contributed substantially to her family income, earned her certification (CPP) from the Professional Photographers of America (PPA), won photography awards in national competitions, and was a respected businesswoman in my community.

Defining my vision helped make it a reality because it helped me focus my time and energy. Over the years I earned my CPP, I was awarded a bronze medal from the Professional Photographers of America for photographic artistry and an accolade of excellence from Wedding and Portrait Photographers International (WPPI), I became an active and engaged businesswoman in my community, and my income contributed to my family's well-being.

Your vision should lift you up and energize you. It will tell you where you want to go and why you want to get there. It will be the driving force that motivates you to work on your business even when you don't feel like it or

when the going gets tough. Having a clearly defined vision will help you persevere through setbacks and frustrations as you begin your journey.

> *"The secret of getting ahead is getting started. The secret of getting started is breaking your complex overwhelming tasks into smaller manageable tasks, and then starting on the first one."*
>
> — *Mark Twain*

Chapter 2. How Will You Get It?

Now that you've identified your basic goals and why you want to achieve them, you need to create a roadmap to accomplish them. Enter the business plan.

Many photographers will skip this step and just grab a camera, set up a Facebook page, and start charging. But I urge you to set aside some time to think this through and write your ideas down. If you review your business plan at least monthly, it will be invaluable in guiding the decisions you make in your day-to-day operations as well as investments in your business. It can also make you more aware of ideas and opportunities that might help you achieve your goals.

The level of detail in a business plan can vary tremendously, but a straightforward one serves a fledgling business well. It can be difficult to develop a comprehensive plan that will work over the long run if you've never actually worked in a photography business, so keep it simple. And, remember: a business plan is intended to be a work in progress, not an ironclad document that can't be adjusted when circumstances change. You don't have to get it absolutely right the first time.

So, what should be in your first business plan? My first was under two pages, and it included:

* *A mission statement*: a reworking of my what and why.
* *My ideal client*: a statement of who I wanted to photograph and who I needed to reach to bring my ideal clients to my business.
* *Revenue objectives*: the amount of money I wanted to earn.
* *Business strategies*: an outline of how I intended to attract my ideal clients and convert them to paying customers, as well as a target number of clients and the average fee their

order needed to total in order to meet my revenue objectives.

After you've been shooting for a year, you can refine and expand your business plan by asking yourself more specific questions such as:

Did you meet your goals? Why or why not?

What has gone right in your business?

What areas are stress points?

How can you improve upon those stress points?

What type of photography do you like best?

Which type of photography is most lucrative for you?

Who exactly are your ideal clients?

Where can you find those clients?

How can you best market to those clients?

What education and training do you need to advance your career?

How can you maintain a steady revenue stream throughout the year?

Who are your competitors, and how will you differentiate yourself from them?

There are many excellent resources available to help you create a more detailed business plan, and I've listed some of them on my website, www.123LaunchIt.com/Resources.

> *"Obstacles don't have to stop you. If you run into a wall, don't turn around and give up. Figure out how to climb it, go through it, or work around it."*
>
> — *Michael Jordan*

Chapter 3. What Can Stop You?

Talking about obstacles might seem a little negative, but it's important to acknowledge and plan for potential obstacles while they're still an abstraction rather than a soul-sucking reality.

Below are some common obstacles that you may face.

1. TIME MANAGEMENT

I recently came across something on my Facebook feed that said, "You have the same number of hours in a day as Lin-Manuel Miranda" (the playwright and Broadway star of *Hamilton* and an overall genius). My friend posted sardonically underneath, "I don't

actually think this is true!" I laughed, but the quote was thought-provoking.

We do all have the same number of hours, each and every one of us. Much of the variability in what we're able to accomplish is in our energy level and in our ability to manage the competing demands on our time. Some of this is in our control, and some of this isn't.

How do you spend your days? What fills up your time? If you're not sure, try keeping a log or use an app to record the things you do every day for a week. I prefer a written time log because I also like to record how productive the activity was and how I felt after doing it.

Ideally, you want to continue to do things that energize you and are productive, and you want to reduce or eliminate those things that are energy depleting or unproductive.

For example, if you spend thirty minutes a day looking at Facebook and then feel strangely depressed, that's thirty minutes you could easily eliminate from your life. On the other hand, if that time on Facebook helps you feel connected with far-flung family and friends and makes you happy, it's a meaningful activity and you don't necessarily need to cut it back or eliminate it.

What Can Stop You?

Once you've identified activities that are energy depleting, see if you can:

Eliminate it. If it isn't productive and doesn't need to get done, just stop doing it. If it's a habit, like scrolling through Facebook whenever you have a few spare minutes, you may need to come up with a productive replacement activity, such as a brain-training game or reading a book.

Develop a more efficient process. Some activities need to get done, but they may not energize you. For example, if you spend an hour a day cooking meals and that depletes you, can you spend a few hours on Sunday and do most of the weekly meal prep ahead of time? Or can you double up your meals and freeze some for another day?

Delegate it. Similarly, can you delegate tasks within your family — for example, teach your children or husband to help with laundry or meals or homework? Can you hire someone to help, or barter with a neighbor? Can you organize a neighborhood carpool to take your children to activities?

Note that some activities may be quite energizing but aren't necessarily productive. Things like Netflix binges, extended phone calls, web surfing, shopping, and so on might fall into this category. You don't need to eliminate these activities completely — it's important to do things that make you happy, regardless of their actual utility. But if you're time strapped and you want to start a business, it's worth looking closely at these activities and seeing if you can spend less time on them.

Don't focus on or become resentful about activities you must do that aren't in your control. For example, if your husband has a job that requires him to be away from home four days a week, that's going to create more work for you. But brooding over your misfortune can be depressing, saps your energy, and doesn't solve your time problem. Focus your attention on the things within your control.

Another aspect to time management is planning your day. The structure of your day can have an enormous effect on your productivity and accomplishment. I'm a firm believer that every day needs to have some breathing room, some unstructured time to do

things that help you relax or recharge. But I also believe that a day that begins with a plan is tremendously more productive than a day that simply unfolds and leaves you reacting to the biggest crisis of the moment.

The best planners allow you to schedule your daily activities while providing space for you to track your weekly goals and objectives.

Remember, it's OK to start small — you don't have to solve all of your time issues in one fell swoop. That can be overwhelming. But if you can do just one or two things to give yourself an extra thirty minutes a day to work on your business, it is absolutely worth doing.

2. YOUR ENERGY LEVELS

We are not all wired with the same amount of energy. And I think it's important to understand and respect our natural biological tendencies. Those differences are evident from childhood — some children are always in motion and love to run and jump and play outside, whereas others prefer to curl up with a good book or sit quietly to study ants or blow bubbles.

But there is a difference between feeling exhausted and run down and moving through

life mindfully and slowly so you can smell the roses. If you're tired and lethargic, that's worth addressing. Begin with a physical from your doctor to rule out a medical cause.

Your energy levels are affected by how you manage stress, how well you sleep, how much exercise you get, and what you eat. So take a look at how well you're doing in these areas and develop strategies and habits to promote and nurture your energy.

This can seem counterintuitive — if you are stressed about not having time and energy to get things done, how are you going to find time and energy to make changes?

It may seem daunting, but the secret is to begin with little steps. By making small, incremental changes to increase your energy, you'll be able to accomplish a little more every day, increasing your feelings of well-being and accomplishment. These feelings will fuel your ability to make larger changes to increase your energy, which will lead to more positive feelings. Remember what is at stake, and just begin. One day at a time, one baby step at a time.

Stress Management. Reducing the amount of stress in your life and improving the way you respond to stress will increase your energy. There are so many techniques and programs that can help you with this. These are some of my own personal favorite strategies:

Connection. First and foremost, having people in my inner circle who I can talk to openly and honestly, without fear of judgment, about whatever is on my mind is essential to my well-being. I regularly seek them out and spend time with them, and that always lifts my spirits.

Centering. I've always been a thinker, and that can lead to paralyzing rumination if I'm not careful. To combat that, I do a simple grounding exercise where I close my eyes and take five to ten deep, calming breaths. Then I open my eyes and bring my attention one by one to all things in my environment that I can see, hear, smell, or touch. This roots me in the present moment and calms my mind because I realize that what I'm worrying about is not actually in front of me right now.

Gratitude. It also helps me to spend time thinking about the things I'm truly grateful for in the present moment and then taking the time

to experience that gratitude physically as a warm rush of happiness and thankfulness, rather than just mindlessly listing my blessings.

Mindfulness. I've also started meditating and practicing YouTube yoga almost every day. Sometimes I only have time for five minutes, but that can be surprisingly beneficial. I prefer to do at least twenty minutes a day. While meditating and/or practicing yoga, I also use an essential oil diffuser. The essential oil centers me and has an added benefit: my mind starts pairing the scent with the feelings I get when I meditate. Now, if I don't have time to meditate, I can simply warm a drop of essential oil mixed with carrier oil in my hands and breathe it in a few times, and I'll feel more calm and relaxed.

Play. Finally, I try to make time for hobbies and things I like to do. Carving out this time is admittedly very difficult, but it makes me very happy and calm when I manage it.

These strategies may not work for you, but it's important to begin figuring out what does work. If you have no idea, just start trying different options and keeping track of what is effective for you.

What Can Stop You?

Sleep. Many studies prove the health benefits of a good night's sleep, and most of us know that sleeping poorly makes us feel terrible and irritable and unable to concentrate or focus. If you're a poor sleeper, start trying strategies to change that.

Common strategies for a restful night include having a bedtime routine, waking and sleeping at the same time every day, avoiding looking at electronic screens shortly before bedtime, increasing exposure to bright light during the day and dim lights in the evening, and avoiding large meals before bedtime.

My husband's office is in our bedroom, so I also need to cover all the blue and white lights on his computer equipment and routers so that our room is dark. I've also found that a comfortable mattress and pillow, a weighted blanket, and a white-noise machine have significantly improved my ability to fall and stay asleep.

Exercise. Exercise is another one of those things that everyone knows is good for their health, yet many of us find it challenging to incorporate it into our lives.

If you're not ready to hit the gym and begin working out regularly, there are other ways to get yourself moving more every day. Walk everywhere, as much as you can. When you drive someplace, park far from your destination and walk. Use stairwells instead of escalators. If you own a dog, walk it! If not, call up a neighbor and meet for morning or afternoon walks. On weekends, go for hikes with your family. Learn some simple stretches and do them regularly. Stretch when you wake up, when you're watching TV, or while you're waiting for dinner to cook. Purchase some hand weights and do some simple exercises while you're watching TV. While you're at it, try some planks or some sit-ups.

There are many specialized exercise options to consider, too, such as swimming, Jazzercise or Zumba, dance, rock climbing, yoga, martial arts and Tai Chi. With enough research, you're certain to find an option you enjoy that's within your budget. And if you can't find real-life classes to attend, the internet makes many of these options viable.

Nutrition. What you eat and how often you eat can have a tremendous impact on your

energy levels. There are many different diets and philosophies about food, but most of them advocate three things: one, eating plenty of vegetables and lean proteins; two, reducing processed foods, added sugars, and refined carbohydrates; and three, drinking lots of water and staying well hydrated.

I will be the first to admit that I don't do any of this perfectly. Fortunately, perfection is not a requirement to feeling better. Do as many of the energy enhancing activities as you can, whenever you can, and I'm confident you'll still experience an improvement.

3. HOW YOU START YOUR DAY

Intuitively we understand that the way we begin our day matters, yet few of us make a conscious effort to design our mornings. We've formed habits over the years that may constitute a routine of sorts — drink two cups of coffee, brush our teeth, pack the lunches and get the kids off to school, walk the dog, take a shower — but they don't add up to anything very meaningful.

A morning routine is a series of carefully curated life-enhancing activities and habits that you begin when you wake up. Hal Elrod

popularized the concept with his book *The Miracle Morning*, but morning routines have been used by productive people throughout history, including Marcus Aurelius and Benjamin Franklin.

What should you include in your routine? That's entirely up to you. A morning routine is intended to get you off on the right foot, so make sure everything in your routine is energizing or productive for you. Here are some common elements:

Planning your day. Look at your schedule, remind yourself of meetings and obligations, map out dinner, and set some goals to achieve by the end of the day.

Writing and reflection. Morning pages, a concept popularized by Julia Cameron, are very popular. The idea involves filling three pages with writing every single day without any self-editing or -censoring. It's intended to be a free-form stream of consciousness. You could also write in a journal and set a time limit rather than a page goal.

Exercise. Whether it's simple stretches, a yoga routine, walking two miles or working out for an hour at the gym, most morning routines include moving the body to get the blood flowing and provide an energy boost.

A nutritious breakfast. An ideal breakfast includes protein, slow-to-digest carbohydrates, and fruits or vegetables. Drink lots of water too!

A positive mindset. Give yourself a pep talk in the morning. It can be through prayer, meditation, reciting affirmations, setting daily intentions, writing in a gratitude journal, practicing visualization, etc.

Continuing education. Few of us have the time or money to attend in-person courses or workshops regularly, but there are many other opportunities to enhance your knowledge such as reading a book, taking an online class, or perusing educational blogs. If you can dedicate ten or twenty minutes a day to learning something new, by the end of a year you'll have made pretty significant progress.

Morning routines are typically thirty minutes to two hours long. This makes them difficult to implement immediately, and you don't have to. You can begin with ten- or fifteen-minute increments.

For example, if you normally get up at seven a.m., try getting up at 6:45 and adding one or two activities to your morning. In a week or so, get up fifteen minutes earlier and extend the previous activities or add a couple more to your routine. By building up your routine in this way, you're more likely to stick with it.

4. FINANCIAL RESOURCES

Some people have ample resources to start their business, and others don't. That's life; it's OK. Not having a lot of extra income to invest doesn't disqualify you from starting a photography business. With some patience you can still make it happen.

I strongly discourage going into debt to start your business, especially if money is already tight for you. Debt will be a source of stress that might lead you to make unhealthy decisions for your business and your life, such as agreeing to photograph an eight-hour

wedding for $200 because you desperately need to pay off your new lens.

It's OK if you don't have the money to buy a professional camera. You can learn the fundamentals of composition on any camera, even a phone camera. When I first became interested in photography, I snapped thousands and thousands of pictures on my point-and-shoot and got feedback on them from photo-sharing websites like Flickr as well as my local photography group. I learned so much about composition and what makes an effective image, and I made good friends and had a lot of fun. Some of these images are still among my favorites.

While you're learning composition, you can brainstorm ways to save money for your camera. Can you teach a skill? Can you offer a service to friends — such as painting or decorating or providing childcare? Can you sell items on Ebay? Can you hold a yard sale? Can you tell family and friends to gift you money for your new camera instead of buying birthday or Christmas presents?

I began writing flash cards after the kids went to bed for an online educational company, and a few months later I had earned enough to

purchase a used SLR, off-camera flash, and professional-grade lens for under $1,000 from someone in my camera club. With my new gear, I began building my portfolio using friends and their families as my models. I continued to write flash cards, and in a few more months I had earned enough to purchase a laptop and some software.

So don't let money challenges deter you from your dream. It took me over ten months to acquire the equipment I needed to launch my business. During that time I was busy learning and improving my photography skills and laying the foundations for future success. You can do this, too.

5. NEGATIVITY

Not everyone will be thrilled that you want to launch a photography business. There may be some resistance from within your own family, your friends might think you're crazy, or you might stumble across an online forum where other photographers tell you the industry is dead. And sometimes it isn't others who fill your head with negativity — it's you and your self-doubts.

Negativity in your home. There are many reasons your family might not support your photography business. Your kids might experience separation anxiety when you leave for a shoot. Your husband might be worried about finances or the fact that he'll need to help more with dinner preparation and the like.

Don't automatically say to yourself "My husband hates the idea, and the kids will miss me, so I'll just wait until _____ [fill in the blank]." Your dreams matter now and are worth advocating for, so make an effort to understand your family's concerns.

Once you know what their objections are, brainstorm possible solutions. If you can't come up with any off the top of your head, search for ideas online. I guarantee you that someone else has had the same problem, and a few minutes using an internet search engine such as Google or Duck Duck Go will lead to several strategies.

Once you have a few options, you and your family can pick the best one. There should be some give and take from both sides — i.e., everyone might not get exactly what they want. Women, especially mothers, often place the needs of others ahead of their own. If this

caretaking and self-sacrifice makes you feel useful and needed, that's certainly valid. But it's still not a reason to forget about your own needs and dreams. Engaging your family in a conversation about how their help can contribute to making your business a reality can teach them the value of working together.

Negativity from friends. We'd like to believe our friends are our biggest cheerleaders, but that's not always the case. You may have friends who seem disinterested in your plans or who actively discourage you. If this happens, remember that you don't actually need their support to push onward. It's lovely to have it, but it's not necessary.

Consider your friend's motives with curiosity and compassion. Don't assume they're jealous or that they never really liked you. Perhaps they're trying to protect you from experiencing failure, or perhaps they grew up with hypercritical parents who always looked at the downside of any new idea.

Find people who understand what you're trying to do. A number of free and fee-based photography forums and communities are on the internet. I've belonged to a few paid forums,

as well as a number of free Facebook groups, and they all have their strengths and weaknesses. Join a few free ones and see if any give you the right balance of encouragement and inspiration.

Consider attending in-person workshops, classes, Meetup groups and photography clubs. They can be a great source of inspiration, friendship, and used camera equipment!

Negativity from photographers. Some of the most vitriolic resistance to women with dreams of starting a business comes from other photographers.

A common question women ask in any online photography group is, "Am I good enough to charge for my work/start a business?" I completely understand the desire for validation behind this question, but please know you absolutely do not need anyone's approval to start your business. All you need is a demand for your work (that is, people who are willing to pay you for your photography) at a price that seems fair to you, and a reliable and consistent way to produce what your clients pay you for.

123 LAUNCH IT

There is no litmus test to launch your business. You don't need a seal of approval from any other photographer or organization.

Photographers, especially those in your area, may be concerned about the impact your business could have on their revenue. This is a pretty natural response. It isn't easy to run a business, and newcomers are a potential threat. Technology has dramatically reduced the cost of starting a photography business, so there are more professional photographers than ever before.

In addition, new photographers usually price themselves lower than established photographers, making it more challenging for higher priced photographers to communicate the value of their work and continue charging premium prices. These photographers might make demeaning comments about you and your photography.

Other photographers are more concerned about preserving their preferred standard of artistry in the industry. For example, classically trained portrait artists might not like the modern styling of natural light and blown-out skies, or they might not like seeing photography rules being broken repeatedly by newcomers.

Sometimes their comments can be scathing. These photographers will claim to be telling it like it is, but I recommend avoiding forums where such brutal feedback is common.

Please don't let these photographers discourage you — their problems are not your fault. The digital age has brought uncertainty and change to many industries. Graphic designers, accountants, musicians, videographers, and so on, are all experiencing major upheavals in their field. Remember that every established photographer was once a beginner like you. Their photography style and business practices evolved over time, and you have every right to launch a business and evolve too.

Negativity from yourself. I loved the Disney movie *Inside Out*, because at its core it's about integrating the different voices and feelings we all have inside of us. Sometimes fear takes center stage, and we might have thoughts like "I can't do this," "I'll never succeed," "I don't have what it takes," or "I'm too shy."

Fear can feel all-encompassing, but it's just one emotion that's hogging the stage. The hopeful you who picked up this book, the

creative you who loves photography, the brave you who articulated your dreams and started your business plan — they're still inside of you. They need to rally together and face your fear.

Fortify those positive emotions. Pull out your business plan and read it again, embracing the courage and optimism you had when you created it. Dig through your Facebook profile and e-mails for compliments about your photography and write them down or put them someplace where you can find them easily again. Print out your favorite photographs and keep them near your computer to remind yourself of your creative talent.

Once you feel properly encouraged, it's time to go back and face your negative thoughts. Take a sheet of paper and draw a line down the middle. On the left, write each negative, fearful thought down. When you're finished, use the right column to respond to your fear in a kind, encouraging way that both acknowledges your negative feeling and refutes it with a factual "but" statement.

For example, next to "I can't do this!" you could write "It's natural to feel overwhelmed and afraid when starting something new [an acknowledgement], but I am perfectly capable

of breaking down my big dreams into manageable chunks and knocking them out one at a time, just like I did when I wrote my thesis [a refutation]."

And so on. By paying attention to your self-messaging, you can take the megaphone away from your negative emotions.

6. COMPARISON PARALYSIS

Be wary of the line between being inspired and being demoralized when you're looking at websites, Instagram feeds, portraits, number of clients, and pricing of other photographers. Perhaps an acquaintance started a photography business six months ago. Now she's out there killing it with her stunning maternity and newborn pictures while you're reading your fourth book on starting a business. Perhaps you've been looking at other photographers' pages on Facebook or Instagram and despairing of ever achieving a fraction of their artistry or client volume.

Pay attention to how you're feeling and what you're thinking when you're studying other photographers. The moment you stop feeling inspired and start feeling despair, shut down the computer and do something else.

Reassure yourself that there are many ways up the mountain of success. Your path is unique and different.

Whatever your obstacles, whatever your gifts, you can take the hand you've been dealt and create beautiful portraits for clients. You can treat your clients like gold and connect with them on an authentic level. And you can build your business at your own pace and find meaning and success.

2
PLAN IT

> *"A lot of photographers think that if they buy a better camera they'll be able to take better photographs. A better camera won't do a thing for you if you don't have anything in your head or your heart."*
>
> — Arnold Newman

Chapter 4. Acquire Your Gear

I love this quote. It serves as a reminder that the camera is just a tool for the person behind the camera. The real art happens in the photographer's brain, in the act of deciding what snippet of life to preserve in an image.

A professional photographer truly needs only three things: a camera, a lens, and a computer with some software. The rest is icing on the cake, no matter what the advertisements or other photographers tell you. If you're tempted to buy something for your business, look at your business plan and make sure the purchase supports your goals and that you can afford it without going into debt.

1. A CAMERA

To launch your photography business, you need a digital single lens reflex (SLR) camera to produce the quality of work that most people expect of a professional photographer. Exceptions would be if you were planning to shoot with film, or if your creative vision for your business were built around unique photographic equipment, like a pinhole or Polaroid camera.

There are two types of SLRs: full-frame and cropped-sensor.

Full-frame cameras are typically more expensive, more durable, heavier, and of higher quality. Many can take pictures in extremely low light. One of the most important differences is that a full-frame camera's sensor (a device inside the camera that records the image — the digital version of film) is the same size as a 35mm film camera's. That means when you use a 50mm lens on a full-frame camera, the picture will look the same as it would if you had taken it with a 50mm lens on a film SLR camera.

A cropped-sensor is smaller than a full frame sensor. That same 50mm lens on a cropped-sensor camera will record less of the

scene, because the sensor is smaller. The image will appear to be zoomed in closer to the subject, because the sensor isn't large enough to record the edges of what the lens 'sees.' Cropped-sensor cameras are lightweight and more affordable than full-frame cameras, and it's not uncommon for a new photographer to launch their business with one.

You can take beautiful pictures right away with an SLR by using the automatic, or program, modes. As you learn more about your camera, you'll begin to explore the creative possibilities with aperture and shutter speed and rely less on automatic settings. As a professional, it's important to understand and learn how to adjust the three elements that control the exposure of your subject: aperture, shutter speed, and ISO. We'll discuss this more later.

2. A LENS OR TWO

After you have your camera, you'll need a lens. Lenses are described by their focal length (how far the lens is from the camera sensor), and their maximum aperture (how much light the lens allows onto the sensor when it's open to its widest setting).

Focal Length. The shorter the lens focal length, the more of a scene the lens will capture. So a 35mm lens will show more of a scene than a 400mm lens. If you stand on the ground and take a picture of a bird in a tree with a 35mm lens, you'll probably capture the entire tree and the bird will be a speck. If you use the 400mm lens, your picture will show a few branches and a close-up of the bird.

Which is better? It depends on the type of photography you do. If you're a landscape photographer, you'll prefer the 35mm lens. If you're a bird photographer, you'll prefer the 400mm lens. It also depends on your personal preferences. The larger the focal length, the heavier the lens.

One more note. The human eye sees the world at 50mm. When you look at the world through a 50mm lens, it'll look pretty much the same as it does when you put the camera down. Lenses with focal lengths below 35mm are considered wide-angle lenses, and lenses with focal lengths longer than 70mm are considered telephoto lenses.

Zoom and Prime Lenses. Lenses are either zoom or prime lenses.

Zoom lenses allow you to change the focal length of the lens. In other words, you can twist your lens and increase its focal length so the subject appears closer to you. Twisting it in the opposite direction will decrease the focal length so the subject appears farther away.

Prime lenses have a fixed focal length and don't allow you to zoom in and out. To get closer to your subject, you need to walk closer to it, and to get more of the background in your picture, you need to walk farther away.

Which is better? Again, it's a matter of preference. Prime lenses tend to be lighter than zoom lenses, and the quality of background blur can be especially lovely. Zoom lenses offer a lot of flexibility, and it can take several prime lenses to cover the same focal range as one zoom lens.

Aperture. Aperture refers to an opening inside your lens that allows light to hit your camera's sensor. Aperture size typically ranges from f-stop 1.2 (or f1.2) to f-stop 22 (or f22). The smaller the f stop, the larger the opening/aperture, which allows more light to hit the sensor. The larger the f-stop, the smaller

the opening/aperture and the less light that hits the sensor.

Every lens has a maximum and a minimum aperture setting. Maximum refers to the widest opening of the lens, and minimum refers to the smallest. Most photographers are more concerned with the maximum opening, so that's the f-stop that's typically used to describe a lens (along with the focal length). So a 50mm f1.2 lens has a higher maximum aperture than a 50mm f1.8 lens.

Lenses with higher maximum apertures are more expensive and heavier than other lenses with the same focal length because they have more glass, which allows them to function well in low-light situations and dramatically improves the quality of the background blur (bokeh). A Canon 50mm f1.8 lens is under $150, whereas a Canon 50mm f1.2 lens is about $1,400.

Some zoom lenses have variable apertures, which means that the maximum aperture changes as the lens zooms out. For example, the Sigma 150-600 f5-6.3 lens has a maximum aperture of f5 when zoomed out to 150, and f6.3 when zoomed in to 600.

Other zoom lenses are constant. For example, the Canon 70-200 f2.8 can open up to f2.8 at both 70 and 200. Constant-zoom lenses are very desirable, as you don't have to adjust your ISO or shutter speed when zooming in and out to take a picture, but they are also more expensive.

Which Lens Should You Purchase? The answer to that question depends on your objectives and your budget. Different lenses perform differently; the same image taken with another lens will have a different look and feel.

The 35mm prime lens, for example, is known as a story-telling lens. It allows you to capture a subject but also to incorporate the environment around it, giving the picture more context and meaning. It would be a wonderful lens if your interest were in street photography, photojournalism or landscape. The Canon version of the 35mm lens comes in f1.4 and f2. The f1.4 will function better than the f2 in low light but will also cost considerably more.

The 100mm prime lens is a beautiful portrait lens. The macro version allows you to take detailed shots of things like jewelry, insects, or flower stamens.

In the zoom lens category, one of the most popular lenses is the 24-70, which is known as a "workhorse" lens. It's perfect for photographing events like weddings, as you can shoot story-telling images as well as portraits and some lovely detail shots. The other is the 70-200 lens, a beautiful portrait lens and another workhorse for portrait photographers. The Canon versions of these lenses come in either f2.8 and f4. Again, you'll pay more for the higher-maximum-aperture lens.

One way to compare the performance of lenses is to search Flickr (http://www.flickr.com). You can type the brand, focal length and aperture of the lens you're interested in in the search bar, and Flickr will pull up images that have been shot with that lens. By scrolling through the images, you'll get a sense of the type of work that lens can produce

My Recommendations. If you have less than $200 to spend, I recommend a "nifty-fifty," or a 50mm f1.8 prime lens. The nifty-fifty is inexpensive but very popular and very versatile. If you start with this lens and use it

daily for a few weeks or even months, you'll get an idea of what your next lens should be.

If you're always thinking, "I really want a more beautiful background blur," then your next lens might be an 85 f1.4 or 85 f1.2.

If you're always thinking, "I really wish this was a zoom lens," you might want the 24-105 f4 or 24-70 f2.8.

If you get frustrated because you're always thinking, "I really wish I could get a better picture of my kids on the football field," you might want to invest in a 100-300mm lens.

Or maybe you'll love the 50mm f1.8 lens and want to upgrade it to the f1.4 or f1.2.

If you have a little more money, I'd recommend starting out with both a prime and a zoom. I started out with the Canon 24-105 f4 and the Canon 50 f1.8, and those two lenses enabled me to shoot a variety of events and portraits. I eventually added the Canon 70-200 f4 and the Canon 100mm f2.8 because I came to love photographing portraits more than events, and those lenses are excellent and relatively affordable portrait lenses.

I have quite an arsenal of lenses now, and I shoot with two cameras so that I can capture a wide variety of images for my clients. My gear

bag is heavy! But I know many photographers who fall in love with one or two prime lenses and use them exclusively.

You can visit my photography website www.goodhartphotographyva.com/Resources to see exactly what's in my camera bag.

3. A COMPUTER

The last necessity for your business is a computer. At the very least, you'll use your computer for storing and editing your images, creating marketing materials and business documents, tracking your business finances, and taking advantage of online education and training.

It will be an indispensable part of your photography business, and you'll undoubtedly spend more time in front of your computer than behind your camera.

Ideally your computer will have a fast processor and lots of RAM so that it can handle large files in Photoshop. Purchase as many terabytes of disk space as you can afford, because your photographs will take up a lot of room, and make sure you have a high-quality monitor, because you'll want accurate color in your images.

But it's possible to make do with less-than-optimal equipment, especially when you're just starting out. My first computer was so slow I could click on the Photoshop icon to open the program, then go downstairs and get a soda out of the garage and a glass from the dishwasher (after I emptied it), and make and eat a quick snack. When I'd finally get back to my desk, my computer would still be loading Photoshop. Executing commands was also excruciatingly slow. I made it work because I had no choice, but a new computer transformed my life. I have an iMac and a MacBook Pro now, and I absolutely love them.

So, should you purchase a PC or a Mac? A laptop or a desktop? Those decisions depend on your preferences. Many photographers insist that the color rendering of your photos on a desktop monitor is far superior to that of a laptop and that a desktop is faster, but being tethered to a desk may not work for you, especially if you have small children. A laptop might make more sense.

The bottom line is that there are many excellent computers to choose from, and it's worth taking the time to research what would be best for your needs and your budget.

Backup Systems. Do yourself a favor and make some decisions about your backup system when you purchase your computer. Your hard drive might fail, your kids might spill juice on your laptop, you might trash the wrong folder, or clients might want to re-order images years later. A good backup system will protect you and your clients from mistakes, accidents, errors, and hard-drive failures.

You have several backup options, ranging from external drives to cloud-based backups. If you use an external drive, you can set up systems like the Mac Time Machine, which automatically backs up your computer, or you can regularly drag files to your external drive. Online backups usually happen automatically behind the scenes, and many photographers use a backup service like Backblaze or CrashPlan.

There are pros and cons to each backup system, but don't get too hung up on trying to create a perfect system right away. Any system is better than no system. Just choose something to start with and refine it later as your business grows and your needs become more obvious.

Software. You'll need software programs to edit and organize your photos and to take care of your day to day business activities.

Photo Management and Editing. The majority of photographers use both Lightroom and Photoshop. Adobe has made this virtually a no-brainer by charging just $9.99 a month to use the latest versions of Photoshop and Lightroom.

Lightroom is useful for importing, culling, organizing and managing your digital photos. It's very fast because it works with small image-preview files rather than full-sized files. You can easily tag photos, apply metadata, and create catalogs.

In addition, it's easy to correct exposure and skin tones in Lightroom as well as do minor retouching such as removing blemishes on skin. Lightroom also allows batch processing (changing settings on multiple images at a time), and you can create or purchase presets that allow you to do a series of edits to your photos with a click of your mouse. Many photographers use Lightroom exclusively to prepare proofs for their clients. Lightroom is also an excellent tool for in-person sales sessions.

Photoshop is vital for more extensive retouching, for complex edits such as swapping heads, for more artistic effects, and for creating composites. Photoshop can also be useful for creating albums and marketing templates and so on.

It will take you a very long time to become proficient in these programs. I've been using them for years now, and I probably know only about 30% of their functionality. However, I can do what I need to do quickly. In the beginning, it took me 8-10 hours to edit a session. Now I can do it in an hour or two.

Several books explain how to use Photoshop and Lightroom, and you also can take advantage of the many free videos on YouTube and Udemy. Kelby Training and Lynda.com are two excellent online video libraries for learning these software programs, and I've subscribed to both many times over the years. CreativeLive.com is another excellent online classroom.

Business Software. There are a number of comprehensive online solutions for managing clients. Most of these require monthly subscriptions, but they can be powerful tools. I recently subscribed to 17Hats, a small-business

management program that collects client information, sends clients contracts and invoices, and manages business finances and more. It's not designed specifically for photographers but has excellent functionality, and 17hats adds improvements and refinements constantly. There are several other studio-management systems specific to photographers that you might want to explore, too, like ShootQ and StudioCloud and Pixifi.

Even if you do in-person sales for your clients, you will eventually want the ability to host galleries online. You can do this through your website, as I did for a few years, but then I discovered Shootproof. I use it to host proof galleries for out-of-town clients, for my wedding clients to share their wedding pictures with guests, and as a quick and easy way to deliver digital files. I also use it for my volume jobs (like school variety shows or dance studios), because it can handle ordering and payments too.

You might want to consider some type of software to track your business expenses and revenues, to create documents and contracts, etc., and to track and manage your clients.

The easiest and least expensive solutions? Use a spreadsheet to track your business finances and a word-processing program to create your documents and contracts and to track your clients. I used the freeware Apache Open Office word processor and spreadsheet programs for many years before upgrading to the Microsoft suite.

Software programs can come with steep learning curves, so be patient with yourself. You can learn software programs by diving in and exploring, by reading books and manuals, by taking online or in-person classes, by asking questions in photography forums, by watching videos, or even by using Google to solve specific puzzles. At one point or another, I've done all of the above. Whatever your learning style, you should be able to find a method that works for you.

4. FINAL NOTES

Here are some tips for acquiring the gear you need for your business if finances are an issue:

Purchase Used Equipment. This is especially true if you are a member of a local

Develop Your Talent

photography club. Hobbyist members of camera clubs frequently upgrade their gear. A professional photographer will often hang on to their older gear as backup equipment, but a hobbyist will sell their gear more readily in order to fund the next purchase.

Buying used can require a buyer-beware approach, however, so make sure you're purchasing from someone who is well-respected, has belonged to the club for a while, and is someone you trust.

As an alternative, you can purchase refurbished cameras from places like B&H or Adorama, or even dealers like Canon. These shops often provide limited warranties as well.

I haven't had good experiences purchasing lenses from photographers in online forums, and as a general rule I don't recommend it.

Upgrade as Your Business Grows. You don't actually need a full-frame camera or professional-grade lenses to start your business. Many photographers use cropped-sensor SLRs — in fact, for the first six months of my business that's what I did.

Buying your equipment in stages offers several advantages. First, you can grow with

your gear and learn photographic concepts as you go. It can be overwhelming to have the best SLR and five lenses from the very beginning — professional SLRs come with many bells and whistles, and they can get in the way of understanding the fundamentals of exposure and composition.

Another advantage is that the longer you're in business, the more clearly you can identify the best cameras and lenses for your style and your business and avoid investing in equipment you use infrequently. For example, a studio photographer specializing in newborns will need different equipment from a wedding photographer.

Watch for Sales. If you're not in a rush, you can get some great discounts at certain times of the year such as Black Friday and Cyber Monday.

Also, camera manufacturers are regularly improving their lenses and cameras and releasing new model, which drives down the price of older models. The camera or lens you covet right now could be several hundred dollars cheaper when the next model is released.

"Every artist was once an amateur."

— Ralph Waldo Emerson

Chapter 5. Develop Your Talent

A good photograph contains a clear image and correctly exposed subject that is arranged with other elements of composition in a pleasing manner within the image. It's essential that you have the technical skills to take portraits that are clear and sharp and properly exposed. In order to do that, you'll need to know how to use existing light or how to create light for your images. Creatively, understanding the artistic rules governing composition can make you more purposeful in creating powerful images. Your objective should be to merge the creative and the technical aspects seamlessly to produce beautiful images for your clients.

1. TECHNICAL SKILLS

Exposure. Your image is properly exposed when your subject doesn't appear too dark

(underexposed) or too bright (overexposed) but is perfectly lit (properly exposed). An overexposed image has too much light hitting the camera sensor, and an underexposed image too little.

There are three ways to control the amount of light hitting the camera's sensor: ISO, aperture, and shutter speed. Find these controls on your camera and learn how to adjust them.

ISO is the sensitivity of your sensor to light. Increasing your ISO setting increases the sensor's sensitivity so that it requires less light to record a properly exposed image. All cameras have a maximum ISO setting, however, so you're limited in how much you can adjust it. Some cameras' ISO ranges are quite impressive, making it easy to shoot in low-light situations like dusk or in a home.

Aperture is the size of the opening of the lens. Increasing your aperture allows more light to fall on the sensor, and decreasing it reduces the light. Unfortunately, aperture numbers (f-stops) are counterintuitive — a larger number means a smaller opening. So f4 is a much larger opening than f22.

Shutter speed measures how quickly your camera's shutter opens and closes. Think of a

Develop Your Talent

shutter as a curtain in front of the sensor. The faster it opens and closes, the less light hits the sensor. In low-light situations, you'll typically want a slower shutter speed because it gives the sensor more time to absorb whatever light is in the scene. Shutter speeds are typically measured in seconds and fractions of seconds. A shutter speed of 1/200 is faster than a shutter speed of 1/30.

Understanding the relationship between ISO, aperture, and shutter speed is essential. Your SLR has four basic modes:

Program mode, where the camera automatically chooses your aperture and shutter speed. If your image isn't properly exposed, you can adjust the ISO. Another option is to adjust your exposure compensation. Exposure compensation is an override of the camera's automatic settings, where you tell the camera to either increase or decrease the exposure of the image.

Aperture priority mode, where you set the camera's aperture and ISO, and the camera chooses the shutter speed. If your image isn't properly exposed, you can adjust the ISO or the exposure compensation.

Shutter priority mode, where you set the camera's shutter speed and ISO, and the camera chooses the aperture. As in aperture priority mode, if your image isn't properly exposed, you can adjust the ISO or the exposure compensation.

Manual mode: You select all of the settings for your image. If your image isn't properly exposed, you can adjust the ISO, shutter speed, and/or aperture.

Changing each of these settings has its downside. For example, let's say your pictures are too dark and you need to increase exposure. To allow more light on your sensor, you can increase your ISO, decrease your shutter speed, or increase your aperture.

However, increasing the ISO to the high end of your camera's range can produce grainy pictures.

Decreasing your shutter speed beyond your ability to hold the camera still (heavier cameras typically need higher shutter speeds) will create images with motion blur.

And increasing your aperture too much may give you depth-of-field problems, where parts of your subject are not in focus.

So photographers often adjust two or sometimes all three settings to minimize the negative effects of adjusting one setting to correct exposure.

While it's relatively easy to understand these concepts when they're explained, it can be challenging to implement them, especially when you're on a shoot. Practice repeatedly until these concepts and relationships become instinctive.

Focus. Modern cameras and lenses make it easy to achieve sharp, clear images. However, sometimes you may find your image is blurry or soft (not in sharp focus), or that your subject isn't in focus. Below are the most common reasons for a blurry image:

Motion blur: A blurry image can be the result of motion blur — the ever-so-slight movement of the camera that happens when you press the button to take the picture. To avoid that, keep your elbows down and against your body; at the end of an inhale or exhale, pause your breath; and gently squeeze the button rather than press it.

You can also try increasing your shutter speed or using a tripod. Sometimes

photographers will use a shutter-release cable in conjunction with a tripod, which allows them to trigger the camera without touching it to avoid even the slightest bit of motion blur.

Depth of field: A blurry image can occur when there are problems with your depth of field. Think of depth of field as a band of focus that lies somewhere between your camera and the horizon. Whatever is inside the band will be sharp, and whatever is outside the band will be blurry. Your subject must always be within the band of focus.

Depth of field depends on your lens (wider-angle lenses have greater depth of field), your distance from your subject (the farther away you are, the greater your depth of field), and your aperture (an aperture of f2.8 has less depth of field than an aperture of f22). Select the right lens and the right camera settings for your photography objectives.

For example, landscape photographers generally prefer the entire landscape to be in focus, so they want the maximum depth of field. Portrait photographers generally prefer their subject to be in focus and the background to be gently blurred, so their band of focus will be more narrow. Sometimes photographers want

part of a subject to be in focus — perhaps a baby's eyelashes but not their lips, or a diamond on a ring but not the ring itself — and in this case the band of focus will be even more narrow.

Focus point: A blurry image can be the result when a camera's focus point is fixed on something in front of or behind your subject rather than on the subject itself. Practice will help you correct this. It can also occur when you lock your camera's focus on your subject and then move the camera to recompose the image. If you have a narrow depth of field, this can cause your subject to fall out of the focus range and be blurry.

Shutter speed: You can wind up with a blurry image when the subject moves and your shutter speed is not fast enough to stop the motion being caught. Sometimes this is intentional and can make for a very striking picture. But sometimes it's accidental. You can ask your subject to hold still, or you can increase your shutter speed.

Recalibration: Sometimes your gear needs to be professionally recalibrated or adjusted. But this is the least common reason for a blurry image, and it typically costs upwards of $75, so

it's worth ruling out the other causes before you send your gear in for service.

Light. Understanding light, and learning how to manipulate is one of the hallmarks of an experienced photographer. The section above on exposure discussed how to adjust the quantity of light hitting your camera sensor to create a properly exposed image. This section focuses on the quality of light along three spectrums: hard to soft, warm to cool, and flat to directional.

Hard to Soft. Hard light comes from a small light source on your subject and it creates shadows with hard edges. Think of the sun on a bright day at 3 pm. Soft light comes from a large light source on your subject and creates shadows with soft edges.

Which is better? It depends on the purpose of your photography. A flattering portrait of a person would use soft light, an edgy portrait of an athlete would probably use hard light.

Warm to Cool. Light also has color, ranging from warm to cool. The Kelvin scale measures the color temperature of light from 1000 to 10,000. A candle emits very warm light, and is about 2000 Kelvin. The golden hour, about 1

hour before sunset, is 3400 Kelvin. Daylight is around 5500 Kelvin, and shade is around 7500 Kelvin.

Many natural light photographers prize the warm light during the golden hour and build their businesses around it. But again, your subject and the purpose of your photograph might lead you to prefer cool light, which is more industrial, detached, and distant.

Flat to Directional. Finally, light can be flat or directional. Flat lighting lacks shadows because the light is directly in front of the subject as the subject faces you, or the light completely surrounds the subject evenly, like an overcast day. Photos with flat lighting don't have much contrast or depth, but it can be useful when photographing your art to sell on ETSY, or an elderly person who wants to minimize their wrinkles.

Directional lighting comes in at an angle on your subject and creates shadows. Shadows are necessary to reveal the three dimensional form of a subject, and its texture.

This is an extraordinarily brief discussion of a very complex subject. There are many tools available to photographers to manipulate and shape light, and you'll be a much more versatile

photographer if you take the time to do so. You don't need to learn them all at once, just pick one tool like a reflector, and when you've mastered that add another. Visit the Resources page on my photography website, www.goodhartphotographyva.com, for recommended books.

2. CREATIVE ARTISTRY

Since you're reading this book, chances are you've been producing pictures that win praise and compliments from your friends and family because you intuitively understand a little bit about composition.

What exactly is composition? It's arranging your subject and the other elements of your photograph in a visually pleasing way. Learning the principles of photography composition can help you better understand why your best pictures work so you can produce these types of images consistently.

Highlight Your Subject. Make your subject prominent in the image so that viewers immediately understand why you took the picture. What are you photographing? What exactly do you want the people who see your

images to think or feel? Why are you taking the picture?

There can be a surprising variety of answers to these questions. If you're a portrait photographer, your answer might be to capture the grace of a young ballerina, to preserve an idealized vision of childhood innocence, or to create a natural family portrait focused on relationships.

Compose your image deliberately so that everything in your image leads to, supports, or provides information about your subject. Leave out extraneous elements.

Rule of thirds: The rule of thirds is a fundamental rule of photography governing the placement of your subject for maximum impact — so much so that many cameras have grids in the viewfinder so you can easily position your subject in the frame according to this rule.

The rule of thirds can be best understood by imagining two horizontal and vertical lines dividing a picture into nine equal sections, as in the image on page 64.

123 LAUNCH IT

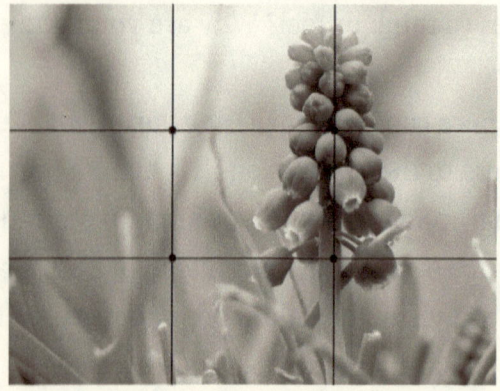

The subject should ideally be placed along one of those horizontal or vertical lines, or at the intersection of those lines. The way our eyes and brains scan images, placing an image along these lines or at these points emphasizes the subject and creates balance in the image.

One exception to the rule of thirds is when you're using symmetry to highlight your subject. In that case, your subject will be in the center of the image.

Framing: Framing is using other elements in your photograph to surround (frame) and thereby draw attention to your subject. For example, if you photograph a cat in a window, the window will frame the cat. If you photograph a bride in a doorway, the doorway

will frame the bride. In the image below, the trees frame the U.S. Capitol Building.

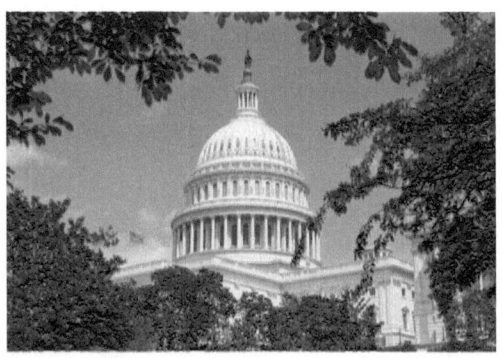

Frames don't have to surround a subject on all four sides; three sides is enough to constitute a frame.

Point of View: Changing your typical point of view when you photograph your subject can also draw attention to it because it creates an unexpected image. For example, most of us as adults look down on our pets. They exist in our mind's eye as they look up at us. If you were to get down on your stomach and shoot up at your pet, the image would be striking because the point of view would be unusual.

Shooting your subject from a lower perspective is called a "worm's eye view," and

shooting your subject from a higher perspective is called a "bird's eye view."

Use the Elements of Composition. The elements of composition are the artistic tools you can use to build your photographs and highlight your subject. There is no official list of these tools; textbooks and websites don't agree and may even use different words to describe the same concept.

Below are my favorite elements, and the ones I consider the easiest to incorporate into a photograph. An element of composition can be used to bring attention to a subject, to balance a subject, or as the subject of a photograph on its own. Photographs usually incorporate multiple elements of composition.

Lines: A mathematical definition of line is the shortest path between two points, which is always straight. In art, however, a line can be curved or straight. Straight lines are direct, strong, to the point. Curvy lines, on the other hand, are gentle and graceful. Eyes follow curved lines more slowly than straight lines, making an image feel more relaxed.

Lines are often used to lead the viewer's eye through an image. These leading lines can

lead to the subject, or to a vanishing point like below.

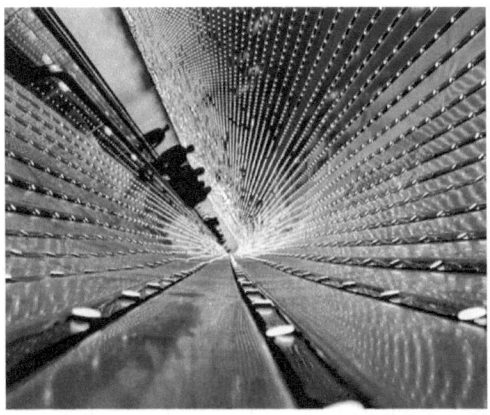

Lines can also divide space in an image. For example, the line of the horizon divides the sky from the land. Lines can also be a fascinating subject in their own right.

Color: The six main colors of the color wheel are red, orange, yellow, green, blue, and purple. Color sets the mood and tone of an image. Each color is associated with certain attributes, and color can be used to set the mood and tone of an image.

Red is a powerful color signifying passion, danger, anger, drama, and love. Orange is an energetic color signifying warmth, harvest, and fall. Yellow is a happy color signifying optimism,

sunshine, and brightness. Green is a fresh color signifying growth, renewal, and nature. Blue is a calm color signifying tranquility, water, and air. Purple is a regal color signifying royalty, mystery, and solemnity.

Black and white also have connotations as well; black is a mysterious color signifying darkness, power, and sophistication. White is a pure color signifying innocence, clarity, and light.

The way colors relate to each other is also important. The main color relationships are complementary (opposite each other on the color wheel), analogous (next to each other on the color wheel), and monochromatic (variations of the same color).

Pictures with complementary colors are vibrant, bold, and energetic. Depending on the other elements of composition, use of complementary colors can draw a lot of attention to your subject.

Images with analogous colors are soothing and harmonious. Pictures of nature often use analogous colors.

Monochromatic images have a contemplative quality to them, and they take on the personality of the color used.

Space: Space is the empty area around subjects and other items in your picture.

Empty space around a subject frames and draws attention to it.

One important rule regarding space: if your subject isn't looking at or moving toward the camera, there should be ample space in the direction the subject is looking. The subject is balanced by the space they're looking into, and the space creates a sense of anticipation and curiosity. Images using space often have a sense of simplicity.

Texture: Texture is the tactile appearance of a surface that tells us whether something is hard or soft, rough or smooth, sharp or flat, and so on. It's revealed in photography by directional light.

Texture can be a subject in and of itself, like a close-up on the bark of a tree, or it can be used to highlight a subject, as in an image of a rugged elderly man where the shadows on his face emphasize his deep wrinkles, making him appear more weathered and weary.

Texture can also draw attention to our subject through contrast. For example, if the elderly man in the previous photo were holding a newborn baby next to his cheek, the texture of the man's wrinkles would accentuate the creamy softness of the baby's skin.

Pattern: Pattern is repetition of a natural or manmade element in your image. Patterns are generally soothing because our brains evolved to make sense of the world through pattern recognition.

Pattern can also draw attention to your subject if your subject breaks the pattern. For example, years ago it was popular to photograph four teddy bears in a row, with a baby being posed as the fifth bear. Attention is drawn to the baby because it's different from the bears.

Putting it all together: While understanding these concepts is rather easy, incorporating them into your photography is much more challenging. Make it a point to practice the elements that you don't use a lot.

For recommended books and classes on photography composition, visit the resource page on my photography website, www.goodhartphotographyva.com/Resources.

*"Knowledge is of no value unless
you put it into practice."*

— Anton Chekhov

Chapter 6. Build Your Portfolio

A portfolio is a collection of your best work that showcases your talent to potential paying clients. You'll use these images on your website and in your social media marketing, such as on Facebook and Instagram. Your portfolio is always a work in progress.

Choose two or three areas to focus on, like families, newborns, pets, maternity, children, high school seniors, or glamour. You may change your mind over time, and that's OK; you can build and change your portfolio as needed as you gain experience. In the beginning, though, stick to a couple of areas so you can become comfortable and feel confident in a few types of photography.

Build Your Portfolio

1. MODEL CALL

The next step is to find models. Before you can put out a model call, you'll need to have a clear, manageable offer for them. You want an offer that will attract models without creating unnecessary work for yourself.

I made that mistake when I was building my portfolio. I offered full ninety-minute shoots for families and promised them an edited CD of all their pictures (between thirty and seventy-five photos) free of charge. Take it from me: that's a bad idea. It was incredibly time consuming, especially since I needed only two or three shots of each family for my portfolio. I recommend offering a thirty-minute shoot and three to five fully edited photos in exchange for a signed model release granting you permission to use the images to market your business.

It's so easy to spread the word once you know what you're going to offer. You can use social media, like Facebook, or networks of people you know through community groups like your PTA or church. You can also send out an e-mail blast to your contacts, or just reach out personally to people you have in mind. I put my model call on Facebook and got over thirty inquiries! Eventually I had to turn people away.

While technically you own the copyright to any photo you take, using images featuring a recognizable person requires a model release. It's best to take care of the model release before rather than during or after the shoot. When someone responds to your model call, send them your release and confirm the date once it is signed and returned to you.

There are many model releases available for purchase, and if you belong to the Professional Photographers of America (PPA) you can download the one they have on their website. Just be aware that laws vary from state to state and that the release may not hold up in court if your model suddenly objects to your using their images. To truly protect yourself, you should have a lawyer in your state read and approve the release.

2. MODEL SHOOT

Plan your model shoot to guarantee success. Every shoot is a chance to practice your technical and creative photography skills. You can practice posing, lighting, composition, and explore locations for shoots to learn where the sun is at different times of the day.

Build Your Portfolio

Beyond acquiring these fundamental skills, it's a great idea to set a specific challenge for each shoot. It could be to get a specific image for your portfolio, such as a picture of a girl in a white dress twirling in a field, or to nail a specific concept or technique, such as getting catchlights in the subject's eyes every single time, or even to incorporate a few elements of composition like leading lines or framing.

Finally, don't forget about the client experience. Treat every model client the same way you envision treating long-time loyal customers. Practice kind and enthusiastic small talk to warm up your clients. Introduce yourself to each member of a family and work hard to remember their names. If you'll be photographing small children, you might create a treasure chest where the children can pick out a treat after the shoot.

These portfolio-building clients will be a major part of your business success. If they love their pictures and love you, they'll be thrilled to spread the word when you're ready to launch your business, so make every effort to give them a great experience.

3. PRODUCT DELIVERY

Even though you'll be delivering digital files, it's a perfect time to think about how to delight your clients when they receive their images. Experiment with different packaging ideas. Go to Office Depot or Michaels and explore ways to package a USB key and make it look pretty. In your package, don't forget to include a thank-you note and a print release.

Even if you decide to make things simple and send images via a file-hosting service like Dropbox, think about the client experience and be sure to send them a thank-you note or a little photo gift of some sort.

After you deliver your images, send an e-mail to each client and ask for feedback. What did they think of their pictures? How did their session go? What recommendations do they have for improving the experience? And if you like what they say, ask them for permission to use their statement as a testimonial. I prefer the casual e-mail to a form or survey, because it sounds more authentic, but many companies such as Wufoo.com let you create a beautiful online questionnaire, and you can send your clients a link to fill it out.

4. WORKSHOP IMAGES

Sometimes photographers will attend a workshop and use the images they create there in their portfolio. This is fairly controversial, even when the workshop host and the model have given their consent. Some photographers believe that you shouldn't use workshop photos in your portfolio because you don't have complete creative responsibility for the image. If a workshop host has set up the image and posed the model and you are shooting over the photographer's shoulder, I see their point. It's not really your work.

On the other hand, sometimes there will be models with whom participants can practice techniques they've learned from the workshop host. If you're responsible for posing the model and setting up the picture, those images are fair game for your portfolio.

The most important thing to keep in mind is that the work in your portfolio should reflect the type of work you can produce. You don't want to fill your portfolio with workshop images taken with the instructor's off-camera flashes if you don't actually own off-camera flashes.

5. THEFT

All of the images in your portfolio should be your work. Surprisingly, some new photographers will download the work of established photographers they find on the internet and crop out the logo, filling their portfolio with the plagiarized images. A number of organizations are dedicated to publicly identifying and shaming photographers who publish stolen work on their website.

There seems to be a perception that images on the internet are free to use. Most images are protected by copyright law. While there are some images that are in the public domain, these images should not be used in your photography portfolio. If you didn't shoot it, don't include it.

6. FINAL NOTES

Portfolio-building is a great opportunity to practice and refine your business processes. Be as professional as possible, even though you are not technically in business. In the next chapter I talk about client-management systems; at the very least, you should have a file folder for each portfolio model that contains their model release and their client-information form. Later,

if you upgrade to a studio-management software system, you'll find it much easier to go back and enter the information.

Take notes after each session. What went well? What needed improvement? What steps could you take to eliminate or reduce the number of things that needed improvement? This is also a good time to set goals for your next session.

Finally, practice delighting your clients, because they will be a key part of your launch strategy. A delighted client becomes a raving fanatic about your business, and the more raving fanatics on board, the faster your business will grow.

Nothing worth having comes easy.

--Anonymous

Chapter 7. Set Up Your Business

Begin setting up your business while you're building your skills and portfolio. It can take a while to complete all the steps necessary to establish a legal business entity, and the steps can be rather tedious.

Please note that every state and county has its own legal requirements, so this section of the book is by no means complete or applicable to your situation. You need to check the laws in your state, city, and/or county. It can be very confusing, but many localities have small-business development centers or organizations like SCORE that provide mentors and help you get started on the right foot.

As a general guideline, these are the steps to setting up a business:

1. Establish a legal business entity.

Set Up Your Business

2. Set up a system to receive and make payments.
3. Purchase insurance.
4. Set your pricing.
5. Develop your business practices.
6. Build your brand.
7. Create your online presence.

1. ESTABLISH A LEGAL BUSINESS ENTITY

Establish your business as a legal entity by choosing a name and a business structure and then registering your business with the appropriate federal, state, and local authorities. Keep all of your important documents in a folder or binder so you can find them easily when necessary.

Choose Your Business Name. The majority of photographers use their last name and add photography-related words like "photography," "portrait studio," "signature portraits," and so on to name their business. This ties your business brand to you personally. You will be the face of your business, and everything you do for your client reflects back on you personally, and vice versa. By using your name, your business comes across as warm and

personal rather than cold and corporate. Plus, your business name is unlikely to infringe on anyone else's trademark.

Other photographers choose names like "Stardust and Pixies Portraits," which allows separation between the person and the business. Missteps in your personal life won't necessarily reflect on your business, and vice versa. You'll have the freedom to shape your business brand into whatever you like, rather than have it be closely associated with you as a person.

Consider whether your name will limit your options in the future. "Stardust and Pixies Portraits," for example, sounds like child/baby photography, so if you decide you want to photograph real estate later, your business name could create confusion for your clients.

Once you've decided on a name, check the United States Patent and Trademark Office website (uspto.gov) to see if the name is already trademarked. Most photographers don't trademark their names right away due to the expense, but keep in mind that if you don't trademark your name, there is a risk another business will choose the same name, trademark

it, and force you to rename and rebrand your business.

Finally, reserve your business name across the internet. For starters, I'd suggest using NameCheap.com to purchase your website domain, and then save your business name on Facebook, LinkedIn, Pinterest, Instagram, Twitter, and any other popular social media network you can think of.

Select Your Business Structure. You have a number of options for the structure of your photography business: Sole Proprietor, Limited Liability Corporation (LLC), S-Corporation, Partnership, or Corporation.

Most new photographers choose sole proprietorship because it's the easiest structure to set up — you only need to register your name and get your licenses. But a sole proprietorship doesn't protect your family's assets from lawsuits against your business and therefore is rarely recommended. It's a common choice however because most photographers don't take the steps initially to establish a better business structure.

As their businesses get more established, however, many photographers change their

structure to an LLC. An LLC protects your personal assets from potential lawsuits against your business by disgruntled clients. This requires a little more work, such as filling out paperwork and paying filing fees, but is a much better option from a personal-liability standpoint.

Finally, some people set their businesses up as a corporation, which has some tax advantages but also takes much more time and effort to establish.

When deciding on a business structure, I recommend talking to someone knowledgeable in your state. You can use free resources through a small-business development center, a Chamber of Commerce, or a SCORE consultant, or you can hire a small-business lawyer.

Register Your Business. To register your business at the state and local level, you'll need to use your social security number or an Employee Identification Number (EIN), which you can obtain from the Social Security Administration. An EIN helps your business maintain a separate identity from you and protects your social security number.

Set Up Your Business

Once you have your EIN, register your business at the state and local level as required. Make sure you understand your state and local legal obligations as a business owner. For example, my local government collects property tax on all of my business equipment. It also required me to obtain a zoning permit to have a physical studio in my home. At the state level, I am liable for sales tax and needed a sales tax permit.

At the federal level, business owners are required to track their business income and expenses and to pay taxes on the difference between them (business profits).

2. MANAGE YOUR MONEY

Your business finances should be completely separate from your personal finances. You'll need the following:

A business bank account. A business bank account is necessary to deposit money and write checks on behalf of your business. Most banks won't let you open a business account without the appropriate local and state paperwork recognizing your business.

A credit card. A credit card enables you ot make business purchases, especially online. Your business card should not be used for personal purchases, and you should avoid making business purchases on other credit cards you may have.

A credit card processing account. A credit card processing account allows you to accept credit cards from clients. I use Paypal and Stripe, which integrate with many of the other software programs I use, but a number of other credit card processing options are available.

A business accounting system. An accounting system will track your business income and expenses so you don't run afoul of federal/state/local laws. It will also be useful for running reports and analyzing your profitability. When you are just starting out, it's easiest to track your finances manually in a bookkeeping register from Amazon or Office Depot.

However, when your business grows and you have more clients, it will be more efficient to use software such as Quickbooks or Excel spreadsheets to track expenses and revenue. It

Set Up Your Business

will make doing your taxes a lot easier, and you can generate some useful reports to help guide your business growth.

Quickbooks is more expensive than Excel and has a steep learning curve, but if you make the effort to learn it while your business is young it will become second nature when your business grows.

An Excel spreadsheet is a much easier option. There are commercially available spreadsheets for photographers that are inexpensive, simple to use, and will give you the numbers you need to pay taxes, manage your money, and analyze your revenue streams and expense categories.

What you want to avoid at all costs is putting all your bank statements, credit card bills, and receipts for the year in a shoebox and trying to make sense of it all the week before taxes are due. That will create countless hours of work and is a huge headache.

3. INSURE YOUR BUSINESS

Insurance can seem expensive to a new business, and many photographers opt not to purchase it initially, but it's worth considering, because things can go wrong. Equipment can be

stolen, and clients are occasionally injured on photo shoots. It's rare, but it happens.

Business liability insurance protects you and your business from personal-injury and/or property-damage lawsuits. Furthermore, many business establishments won't let you photograph on the premises if you don't have it.

Equipment insurance protects your equipment from loss or theft. Make sure you understand your policy's coverage — will the insurance company replace your items at full retail cost or will they give you the depreciated value toward replacement costs? What is the burden of proof on loss or theft?

Indemnification insurance protects you against lawsuits from clients who claim your negligence harms them. For example, an angry client could sue you because you lost the memory cards holding their pictures, or your computer crashes and you can't recover their images.

Your homeowners insurance might offer a rider as an affordable insurance option. If not, many companies provide coverage for

photographers, including the PPA. At this writing it offers its members indemnification insurance, as well as $15,000 of equipment insurance, free of charge. For a fee, you can add equipment coverage and liability insurance.

4. SET YOUR PRICING

Proper pricing is critical to the success of your business. In the beginning, you might think, "Oh, if I earn a hundred dollars I'll be happy! That's $20 an hour, because it takes me one hour to take the pictures and four hours to edit the pictures and burn a CD."

However, the money you earn needs to pay for much more than your time. All businesses have operating expenses such as insurance, website development and maintenance, education and training, telephone services, marketing and advertising, office supplies, and so on. Your pricing must be high enough to cover your operating expenses as well as your investments in equipment and computers (capital expenses). If you sell products such as prints or canvas gallery wraps, your pricing will also need to include the cost of the products you sell.

How do you know what your expenses will be and decide what to charge your clients? After a couple of years in business, you'll be able to use Quickbooks or Excel to analyze your expenses and make an educated estimate. But until then, you can use the PPA's 2014 benchmark survey as a baseline. In that survey, expenses for home-based studios averaged about 50% of sales, and cost of goods sold averaged 20% of sales. That means for every $100 a photographer charged, only $30 of that was profit.

Many photographers don't sell products when they start out; they sell digital files. Let's consider a hypothetical photographer, Jane of Jane Doe Photography. She sells only digital files, so she keeps $50 (instead of $30) for every $100 she charges. If Jane wants to earn $20 an hour and she spends ten hours on her client, then she needs a $200 profit. Since her profit is about half of what she charges, she needs to charge her client $400 for the session and digital files in order to take home $200.

This simplified example takes into account only the desired pay rate per hour, not annual revenue goals or income taxes. To meet your annual revenue goals, your pricing and your

Set Up Your Business

marketing will need to work together to bring the right number of the right clients through your door. That discussion is beyond the scope of this book, but visit www.goodhartphotographyva.com/Resources for more information and resources.

One final note: many new photographers experience pressure from experienced photographers to charge top dollar for their work so they don't "undermine the photography industry as a whole" and make it harder for experienced photographers to sustain their own pricing and revenue targets.

These concerns have some validity, but photography is a highly competitive market. Most new photographers are unlikely to find clients if they launch their businesses with a $2,000-minimum-order requirement and charge $150 for an 8x10 portrait. Few established photographers began their own businesses charging those kinds of prices. They grew and evolved as their business developed, both in terms of their photography skill and their pricing. Your pricing doesn't need to work for other photographers — it just needs to work for you.

5. ESTABLISH YOUR BUSINESS PROCESSES

As you start working with clients, you'll learn that many of the actions you take with each client are the same. It's extremely useful to start grouping these actions together into standardized workflows, rather than winging the steps each time. A standardized workflow will enable you deliver quality products to your client and make it easier to outsource tasks as your business grows.

Your workflows will evolve, so develop a baseline workflow for each photography business process and adjust it as needed. Feel free to research how other photographers run their businesses, but keep in mind that a workflow is uniquely suited to a person's personality and business goals. Therefore a workflow that works for someone else may not work for you.

Below are some of the more common photography business processes and ideas for you to consider.

Client Intake Process. Your client intake process answers questions such as how do you respond to an initial inquiry? Do you require an in-person consult? Does the client need to pay

for the session up front? What type of contract do you make them sign? Do you send them a print or pdf welcome kit? How are you tracking your client's information? Do you use a physical folder, or online software?

Shooting Process. Your shooting process consists of the steps you take during your shoot to deliver an exceptional experience for your client while making sure you get the images you need for a good sale. What gear do you need to pack and prep? Where will you shoot? How many pictures will you take? What are your objectives for the shoot, and how will you make sure you meet them? Will you shoot RAW or jpg images? Will your client change clothes? If so, where? Do you need an assistant to carry your gear and to hold reflectors? How do you know when a session is over? How are you going to prep your client for the sales process? Will you provide your clients with a sneak peek?

Editing Process. Your editing process refers to the process of importing images from your memory card to your computer, as well as preparing the images to show your client. Lightroom is preferred by the majority of

professional photographers because it is easy to import pictures, to tag them, to cull them, to organize them, and to edit them. Some photographers will also use photoshop to do more detailed retouching of proofs for the client.

Some questions to consider here are how many proofs do you want to show your client? Do you want to show fully edited proofs or lightly edited proofs? What will be your naming conventions? How will you back up your images?

Sales Process. Your sales process is the way you sell your images to your client. Will you have a beautifully printed price list? Will you send your client your pricing in advance or show it at the sales session? How confusing is the process? Are they prepared for the session or do they get sticker shock? Will you offer digital files?

There are three major sales strategies, all-inclusive pricing, in-person sales, and an online proofing gallery.

All-inclusive pricing means that the client pays one fee that includes the shoot and a predetermined number of digital files. This is

typically the way many new photographers start their business because they don't have to invest in studio samples and there is a low cost of goods to the sale. However, it limits the amount of money you can earn per client.

In-person sales refers to personally showing your client his or her proofs and conducting the sales session at the same time. This can be at your home/studio, or at the client's home. You can show proofs digitally using an iPad or a computer, or you can use printed proofs.

The advantage of in person sales is that the emotional reaction clients have to their images powers the purchasing decision so sales averages tend to be higher. You can whet your client's desire for products by displaying beautiful samples. You can answer their questions, and offer suggestions and guide their purchase.

The disadvantages are that sales sessions take a lot more time and can be inconvenient. Indecisive clients can drag things on for a couple of hours, especially if you are new to sales. Clients may want to meet you at inconvenient evening hours which could cut into your family time. Finally, you have to keep your sales room clean and inviting, and you

have to figure out what to do with pets and children while you are with your clients.

If you decide to go with in-person sales, pay close attention to what a client will experience from the time they park their car to when they walk into your home or studio. You only get one chance to make a first impression. Keep a fresh coat of paint on your door, and pull weeds in the garden around the entrance to your home. Burn candles or bake cookies so the home smells wonderful, and keep accessories as plush and wonderful as possible.

Most importantly, make sure you have beautiful studio samples, the most expensive and luxurious you can afford. You sell what you show. I have seen this principle in practice many, many times.

Online gallery proofing uses an online gallery to show the proofs to your client. The client reviews the proofs and places their order online, by email, or over the telephone. This is very convenient as you don't need to have a sales room in your house and you don't have to worry about what you are going to do with the kids for sixty minutes in the evening. It's also great for out of town guests or busy clients.

The downside is that many clients procrastinate placing their orders and average sales tend to be smaller because the emotional experience of seeing the images fades before the order is placed.

Order Fulfillment Process. The order fulfillment process consistes of retouching the client's ordered images and ordering the products the client has paid for from professional labs.

Many photographers develop their signature style through their editing and retouching rather than through their photography. Photoshop is an incredibly powerful software tool, and you can dramatically change an image with careful retouching. But that can take quite a bit of time. As your business grows, you'll value an efficient retouching process. I have my own specific process that I've created, along with custom photoshop actions, that allow me to complete the retouching in a fairly short amount of time. I remove stray hairs, whiten teeth, remove skin blemishes, lighten under-eye circles, and do some selective dodging and burning.

Once the images are retouched, you'll need to order the prints and products. Most new photographers use professional labs rather than invest in their own professional equipment. I haven't found one lab for all of my needs, so right now I use Millers for all of my prints and some albums, WHCC for proof books, .and Artsy Couture for canvases. I also use American Color Lab and PCL West for other albums.

Some experienced photographers want complete control over the color of their prints and canvases, and they will choose to invest in professional printers so that they can fulfill orders themselves.

Billing Process. This refers to the way you collect payment from the client for their session and for their order. Will clients be able to pay with a credit card?

In the beginning, I preferred to be paid by check. When most of my orders were just a few hundred dollars, that was fine with clients. But as my sales averages went up, clients wanted to be able to pay with a charge card.

How are you going to record payments and track your sales tax and income? Will you allow

partial payments? How will you handle bounced checks or late payments? What type of receipt will you provide to your clients?

Delivery Process. The delivery process refers to packing your client's orders and getting them in their in their hands.

How do you package your orders? You want your clients to be excited and to love the packaging. How do clients feel when they receive the order? Do they sign off on a delivery sheet? Do you deliver the order or do they pick it up at your home or do you ship it? Do you send a thank you letter or small gift afterwards? Do you add clients to a newsletter or marketing list?

When I started out, I used to deliver my orders to my clients rather than have them come to my home as a way to give them exceptional customer service. That became pretty inefficient however as my business grew. These days I set a specific window of time where I am always home for pick-ups and ask clients come at those times.

And a client-goodbye workflow will answer questions such as how do you ensure client satisfaction with an order? What happens if a

client is not satisfied? Do you send them a survey and/or thank you gift after you deliver their order? Do you follow up with them or touch base on special occasions such as birthdays and holidays?

Bookkeeping Process. This is the process of recording your income from your clients and your expenses relating to your business.

There are a surprising number of photographers who use the "shoebox" method of bookkeeping — which is tossing all of their receipts, credit card statements, and bank statements into a shoebox and then going through them in March to figure out their business income, expenses, and taxable profit.

Do yourself a big favor and try to keep on top of your bookkeeping at least quarterly, if not monthly. The simplest way to get started is to use a business ledger from an office supply store. You can also use a simple Excel spreadsheet, or purchase a spreadsheet designed for photographers by photographers. Many software management programs also include bookkeeping functionality, which allows you to take care of your bookkeeping daily. You can also use smart phone apps to

Set Up Your Business

record your expenses and generate reports that can help you with your bookkeeping.

Quickbooks is another popular software program for tracking income and expenses. It integrates with most banks and Paypal, and also creates invoices. However it is more expensive and complicated than the other options.

6. BUILD YOUR BRAND

Your brand refers to your business's unique qualities and characteristics that are noticed by prospective clients and differentiate you from the photographer down the street. It's one of the most important aspects of your business.

Most new photographers think their brand comprises their logo, their packaging, and the colors on their website. Your brand does include those things, but it's much more. It also consists of your photographic style, your marketing materials, your business practices, and, of course, you!

Photographic Style. If you're like most photographers, your style will evolve as you master Photoshop and Lightroom, learn to manipulate light and direct clients, and learn which subjects you like to photograph. Are you

classic and traditional, edgy and gritty, clean and bright, or vibrant and cheerful?

Even if you're dabbling in many styles, pick one for your website. You can revise and update your website later as your style develops. The pictures you showcase on your website should have a cohesive look and a consistent style so prospective clients know what to expect.

Marketing Materials. Your marketing materials need to reflect and support your photographic style. If your style is edgy and gritty photographs of sweaty athletes scowling at the camera, you probably shouldn't choose pink for your branding colors. What colors represent your brand? What type of logo do you have? What's your packaging like? What do you showcase on your business card or in your printed/online marketing materials? Does your marketing brand serve you well? Does it fit your photographic style and attract your target client?

It's absolutely fine to keep things simple in the beginning. You don't need to spend a lot of money on a branding specialist or marketing materials (although that can be a lot of fun). Many photographers change and refine their

brand identity several times in the first couple of years, so a large investment initially doesn't necessarily make sense.

Business Practices. Part of your brand is how working with you feels for the client. It's how your studio is decorated, your sales processes, and the way the client experiences everything. With your ideal client in mind, design your business practices to appeal to them. For example, if you're a pageant photographer, you'll want your studio to be bright and glamorous and your processes to pamper your clients. If you're a child photographer but your studio is full of crystal, or you are a home-birth photographer but you always wear a suit, you are creating dissonance for your clients.

You. Your brand is also how you present yourself as a person. Everything you do sends a message about who you are and what you value. If you're a wedding photographer, you might not want to share Facebook posts about rising divorce rates or cheating politicians, for example. Being conscious of your brand doesn't mean changing who you are or being

inauthentic. It just means being aware of the signals you send out as you engage with people in your community and on social media.

7. CREATE YOUR ONLINE PRESENCE

Photography is a visual art, and clients will want to see your portfolio before deciding to contact you. Therefore your photography business needs an online presence.

If you are overwhelmed by setting up a website, start with a social media account such as Facebook. Create a Facebook business page from your personal account and invite your friends to like it. This can feel awkward, but most Facebook users are happy to support their friends' business enterprises this way. Now you're ready to begin posting and sharing your work!

Facebook gives you an online presence in just a few minutes. One major disadvantage is that it's a constantly changing medium — it changes the rules, the way the page layouts work, and so on. Another disadvantage is that Facebook is trying to make money off of you, so it shows your posts to a very small percentage of your page fans. To reach a larger audience, you need to pay to promote your posts.

Creating your own website may seem intimidating, but it doesn't have to be terribly difficult. These are the basic steps:

1. *Purchase your website domain name*, also known as your URL. I use Namecheap.com for this because they have great prices and exceptional customer service.
2. *Purchase hosting services* for your website. Many people use one company for purchasing their domain name and another for hosting their website because it can be more secure. Or you can keep it simple by using the same company. Once you pay for hosting services, your web-hosting company will send you an e-mail that allows you to access your control panel. Print this message out and keep it handy.
3. *Install Wordpress*. Most web-hosting companies make this easy, and it takes just one click from your website's control panel.
4. *Select a free or commercial Wordpress template* and begin uploading pictures and writing content. Be sure you choose a "responsive" template so that your website will

be visible on mobile devices as well as on computers.

That's it! Your website will undergo many revisions and updates over the lifetime of your business. It doesn't need to be perfect, but make it the best website that you can, and revisit it at least once a year to update your portfolio. At a minimum, a website gives your business legitimacy and inspires confidence. If you update your website regularly by blogging, it can bring you many new clients through Google searches.

3
DO IT

> *"A ship is safe in harbor, but that is not what a ship was built for."*
>
> — *William H. Shedd*

Chapter 8. Launch Your Business

At last you're ready to launch. Your business entity has been created, your pricing and products have been established, your portfolio has been built, and goodwill has been generated from your portfolio clients. Congratulations!

The next step is to create your launch offer and then spread the word. Believe me, I know it can be tremendously scary to put yourself out there. What if no one comes? What if your work isn't any good? What if people think you're ridiculous for trying to start a business? Shouldn't you wait until your branding material is perfect?

Fear can keep you busy planning and revising, pushing back your launch date ad nauseam. There are business cards to design,

forms to create, pricing to perfect, software to learn, people to talk to, portfolios to refine, and so on. Your to-do list grows as fast as you check something off.

The truth is, there's never a completely perfect time to launch. Launch when you are 75% or 80% ready, and plan to make improvements and adjustments as you go. Have faith in yourself to take care of your clients and to fix what isn't working. If you insist on waiting until you feel 100% ready, you may never launch.

So what should be in your launch offer? That's up to you. It should be something you believe will attract the clients you want and also something you're excited about offering, such as a unique photo gift, a discount, or a special themed session like "Fall Foliage Fun." Add a sense of urgency to your launch offer by including an expiration date. My launch offer was waiving my session fee and offering 50% off my regular prices for one month.

Once you've decided what to offer, create a flyer using some of your best portfolio images. Use Microsoft Word, Photoshop, or a website like Canva to design something eye-catching.

Launch Your Business

Finally, spread the news. Hopefully you've converted your portfolio-building clients into raving fans of you and your work, and they'll be delighted to help you out by sharing your flyer with their friends and families. Next, use your social media networks. E-mail your flyer to your friends and community networks.

Before you know it, your first real, paying clients will walk through the door.

> *"Do what you do so well they will
> want to see it again, and bring
> their friends."*
>
> –Walt Disney

Chapter 9. Wow Your Customers

The first step to wowing your customers is to present them with beautiful images and amazing products. That's what they're paying you for — that's what they expect. Make sure they're not disappointed.

The next equally important step is to provide exceptional customer service. Most people are regularly frustrated by bad customer service experiences — seemingly endless automated telephone menus, disinterested cashiers, high-pressure salespeople, and the like. You and your business can offer a breath of fresh air.

At its core, good customer service is simply being kind and attentive to your clients. Greet them warmly and be genuinely interested in them. They chose you, so they're already predisposed to like you. Listen to them

carefully, respond to them thoughtfully, and try to forge a connection. Answer their questions patiently and never express annoyance if they question your policies or need repeated clarification about something.

Good customer service is also delivering what you promise, ideally before the date you've promised it. It's easy to underestimate how long something will take to deliver, so I recommend you take your best estimate and double it. Life will get in the way of your best plans. It's so much better to deliver your product before rather than after the client expects it.

Deal with customer complaints quickly and promptly. Treat your customer's concerns as legitimate and address them. Consider requests for reprints and other issues as a cost of doing business, and factor that into your pricing. It simply isn't worth your time and energy or the price of your client's goodwill to argue with them about reprinting an 8x10 print.

Build a positive client experience around what's consistent with your brand and natural for your personality. For example, a playful and lively child photographer can build an excellent brand experience around her energy just as

easily as a patient and gentle child photographer can build an excellent brand experience around her quiet presence.

Finally, to really distinguish your business practices from your competition's, run through your business procedures as if you were a customer (or have a friend pretend to be a customer) and develop an attentive, white-glove process to make your clients feel taken care of from the moment they make the first phone call or send that first email to the day they walk out the door with their order.

The components of wowing your customers may seem overwhelming, but you don't need to do everything all at once or before you launch. Paying attention to just a fraction of these things will help your business stand out in a world of frustrating customer-service experiences. As your business grows, you can add more white-glove experiences for your client.

Your mission should be to make every client a raving fan. One happy client can bring in dozens more. Of course, in spite of your best efforts, not every client will become an advocate for your business. You still need to treat every client and potential client with

warmth and respect and give them the best experience possible. Even potential clients who ultimately decide they can't afford to hire you may have friends who can.

> *"Who you are tomorrow begins
> with what you do today."*
>
> — *Tim Fargo*

Chapter 10. Grow Your Business

Clients are the lifeblood of any business. After your initial launch, how do you keep them walking through the door? There are three major sources of new clients: referrals from existing clients, marketing, and reputation.

Referrals. Word of mouth from existing clients is by far the easiest and least expensive way to grow your business. If you provide a product and service that delights your clients and they talk enthusiastically about you to their friends, that carries a lot of weight. People trust their friends.

With that in mind, ask your clients for referrals, especially when you know they're happy with your products. Make it easy for clients to show the images you created to others — sell them portraits that will hang on their wall, give them a proof book to toss in

their purse or a digital app to display their images, or send them watermarked files to share on their social media networks.

Follow up with your clients from time to time; send them an e-mail or a card, tag them in social media, blog about their sessions, or send them a printed or digital newsletter.

Be sure to thank your clients for the referrals they send you. You can send them a handwritten note or a small gift or offer them a free portrait session within the next year. Or you can start a formal referral program where your clients earn pre-determined gifts and rewards for each referral they send you.

Marketing. Marketing is promoting your business so that others know about it. New photographers usually don't have much of a budget for marketing, but, fortunately, there are plenty of free options.

Social media is a wonderful way to raise awareness of your business. Post on your accounts regularly, and make sure to interact with anyone who engages with your posts.

E-mail is another good way to keep your business in people's minds. A number of e-mail managers, like Mad Mimi and Mailchimp, allow

you to send e-mail blasts or newsletters to all of your clients at once. Make sure you send useful information or valuable offers, because all of the e-mail managers allow recipients to mark you as spam or to unsubscribe from your e-mails.

Marketing can be as simple as updating your blog several times a week with fresh and helpful content to improve the likelihood that people searching for a photographer online will come across your website. There are specific strategies for improving your search engine optimization, or SEO, but those are beyond the scope of this book.

The internet is not the only way to build awareness of your business. Local in-person networking events can be very effective. You can find these meetings on Facebook, Eventbrite, and Meetup, among other options.

You can also approach local businesses about partnering with them in a way that benefits both of you. For example, you could partner with a makeup artist to do makeup and headshots at a special rate and cross-promote each other to reach new clients. Or partner with a local clothing store: your clients wear the store's clothing during their shoot and you

provide the store with marketing images for their walls or social media. Or offer a pediatrician portraits of some of their clients (or their own children) to decorate their walls. They get free wall art, and you get free advertising.

Another idea is to donate a photography package to auctions and charity events in your community. I prefer to donate to auctions over raffles. That way, I know the person who ends up with my photography package wanted it.

There are many paid options for marketing, and you'll want to measure the results so that over time you'll learn what's most successful. On the internet, you can buy Facebook, Instagram, and Google ads. Facebook and Instagram are very affordable for small businesses, and I've found ads to be quite effective.

Community displays, like in a local shopping mall, can be expensive but can bring you new clients by showcasing your best work. Sponsoring local charity events and having your business listed as a sponsor (especially if it's on a T-shirt) can also raise awareness of your business.

Some photographers purchase ads in magazines and newspapers, but I personally prefer the targeted advertising of Facebook to the scattershot approach of magazine ads.

Direct mail can sometimes yield results for a large studio, but it's probably going to be cost-prohibitive for a small studio to send out thousands of professionally printed advertising pieces to everyone in a couple of zip codes.

Reputation. A good reputation takes a while to establish. But the longer you operate in your community as a photographer providing quality products and a good experience for your clients, the more your reputation will grow. Strangers will know who you are just from seeing your work on their friend's social media pages, as well as seeing your name associated with different organizations in your community, seeing your ads in their local magazines or newspapers, and so on.

I've had clients referred to me by people who never used my services, but they knew of my business because of my reputation.

Conclusion

I hope this book has helped you move forward with your dream — taking notes, laying the foundation for your business, or perhaps even launching!

If your growth trajectory is a little slower, that's fine too. Look back to where you were when you began this photography journey. Have you made progress, even a little? That's wonderful! Keep plugging away. Have you procrastinated and forgotten whatever you learned and lost your list of things to do and your camera manual? That's OK too. Just begin again — don't let a setback become a reason to quit.

It takes courage to start a business. In addition to producing art and sharing it with others, you must also be willing to experience the discomfort of making mistakes, taking risks, and facing rejection. It's important to view these as learning experiences and not let them discourage you. Any discomfort is a small price to pay for the enormous sense of satisfaction and happiness that comes from connecting with

clients who value what you do and are willing to pay you for it.

So, don't give up. I know you can do this.

Go confidently

in the direction of your dreams. .

--Henry David Thoreau

About the Author

Angela Goodhart is a Harvard educated, award-winning portrait photographer based in the Washington DC area and founder of 123LaunchIt.com. She loves photography, sharing what she's learned with others, and writing, so it made perfect sense for her to combine all three into the book you are holding in your hands.

When she's not focused on photography or teaching, you will find her spending time with her family and friends, hanging out in a coffeeshop with her laptop and planner, creating messes in her art studio, browsing Instagram, or walking her rescue mutt.

Did you enjoy this book?
I'd love to hear what you thought about it! Email me at <u>123LaunchIt@gmail.com</u> or **leave me a review on Amazon**.

Awards and Accomplishments

- *Bronze medalist, 2018 International Photographic Competition (PPA)*
- *Certified Professional Photographer (PPA), 2013-present.*
- *Accolade of Excellence, 2013, WPPI*
- *Member of Professional Photographers Association of America (PPA), 2010-present*
- *Photography Instructor 2013-present*
- *Published in Senior Style Guide, Seniorologie, Posh Seven Magazine, N2.*

Visit

www.123LaunchIt.com,

to download your FREE business plan

and/or receive notice

when I've created

additional worksheets

to accompany this book.

www.ingramcontent.com/pod-product-compliance
Lightning Source LLC
Chambersburg PA
CBHW021825170526
45157CB00007B/2688